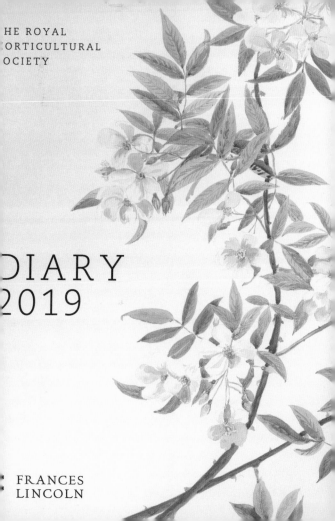

THE ROYAL
HORTICULTURAL
SOCIETY

DIARY
2019

FRANCES
LINCOLN

Royal Horticultural Society Diary 2019
© 2018 Quarto Publishing plc
Text and illustrations © 2018 the Royal
Horticultural Society and printed under licence
granted by the Royal Horticultural Society,
Registered Charity number 222879/SC038262.
For more information visit our website.
An interest in gardening is all you need to
enjoy being a member of the RHS.
Website: rhs.org.uk

Astronomical information © Crown Copyright
Reproduced by permission of the Controller
of Her Majesty's Stationery Office and the
UK Hydrographic Office (www.ukho.gov.uk)

First published in 2018 by Frances Lincoln,
an imprint of the Quarto Group
The Old Brewery, 6 Blundell Street,
London N7 9BH, United Kingdom
www.QuartoKnows.com

A catalogue record for this book is
available from the British Library

Designed by Sarah Allberrey

ISBN: 978-0-7112-3949-4

Printed in China

9 8 7 6 5 4 3 2

Title page Watercolour on paper of *Rosa mosc*
or musk rose, painted in Shimla, India, May 1⁷
Below Watercolour of *Tecoma capensis* or Cape
honeysuckle, painted in Madras, India, 1931.

RHS FLOWER SHOWS 2019

The Royal Horticultural Society holds a numb
of prestigious flower shows throughout the ye
At the time of going to press, show dates for ?
had not been confirmed but details can be fou
on the website at: rhs.org.uk/shows-events

Every effort is made to ensure calendarial dat
is correct at the time of going to press but the
publisher cannot accept any liability for any
errors or changes.

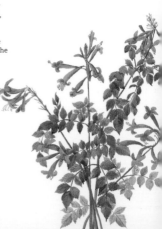

CALENDAR 2019

JANUARY
M	T	W	T	F	S	S
	1	2	3	4	5	6
7	8	9	10	11	12	13
14	15	16	17	18	19	20
21	22	23	24	25	26	27
28	29	30	31			

FEBRUARY
M	T	W	T	F	S	S
				1	2	3
4	5	6	7	8	9	10
11	12	13	14	15	16	17
18	19	20	21	22	23	24
25	26	27	28			

MARCH
M	T	W	T	F	S	S
				1	2	3
4	5	6	7	8	9	10
11	12	13	14	15	16	17
18	19	20	21	22	23	24
25	26	27	28	29	30	31

APRIL
M	T	W	T	F	S	S
1	2	3	4	5	6	7
8	9	10	11	12	13	14
15	16	17	18	19	20	21
22	23	24	25	26	27	28
29	30					

MAY
M	T	W	T	F	S	S
		1	2	3	4	5
6	7	8	9	10	11	12
13	14	15	16	17	18	19
20	21	22	23	24	25	26
27	28	29	30	31		

JUNE
M	T	W	T	F	S	S
					1	2
3	4	5	6	7	8	9
10	11	12	13	14	15	16
17	18	19	20	21	22	23
24	25	26	27	28	29	30

JULY
M	T	W	T	F	S	S
1	2	3	4	5	6	7
8	9	10	11	12	13	14
15	16	17	18	19	20	21
22	23	24	25	26	27	28
29	30	31				

AUGUST
M	T	W	T	F	S	S
			1	2	3	4
5	6	7	8	9	10	11
12	13	14	15	16	17	18
19	20	21	22	23	24	25
26	27	28	29	30	31	

SEPTEMBER
M	T	W	T	F	S	S
						1
2	3	4	5	6	7	8
9	10	11	12	13	14	15
16	17	18	19	20	21	22
23	24	25	26	27	28	29
30						

OCTOBER
M	T	W	T	F	S	S
1	2	3	4	5	6	
7	8	9	10	11	12	13
14	15	16	17	18	19	20
21	22	23	24	25	26	27
28	29	30	31			

NOVEMBER
M	T	W	T	F	S	S
				1	2	3
4	5	6	7	8	9	10
11	12	13	14	15	16	17
18	19	20	21	22	23	24
25	26	27	28	29	30	

DECEMBER
M	T	W	T	F	S	S
						1
2	3	4	5	6	7	8
9	10	11	12	13	14	15
16	17	18	19	20	21	22
23	24	25	26	27	28	29
30	31					

CALENDAR 2020

JANUARY
M	T	W	T	F	S	S
		1	2	3	4	5
6	7	8	9	10	11	12
13	14	15	16	17	18	19
20	21	22	23	24	25	26
27	28	29	30	31		

FEBRUARY
M	T	W	T	F	S	S
					1	2
3	4	5	6	7	8	9
10	11	12	13	14	15	16
17	18	19	20	21	22	23
24	25	26	27	28	29	

MARCH
M	T	W	T	F	S	S
						1
2	3	4	5	6	7	8
9	10	11	12	13	14	15
16	17	18	19	20	21	22
23	24	25	26	27	28	29
30	31					

APRIL
M	T	W	T	F	S	S
		1	2	3	4	5
6	7	8	9	10	11	12
13	14	15	16	17	18	19
20	21	22	23	24	25	26
27	28	29	30			

MAY
M	T	W	T	F	S	S
				1	2	3
4	5	6	7	8	9	10
11	12	13	14	15	16	17
18	19	20	21	22	23	24
25	26	27	28	29	30	31

JUNE
M	T	W	T	F	S	S
1	2	3	4	5	6	7
8	9	10	11	12	13	14
15	16	17	18	19	20	21
22	23	24	25	26	27	28
29	30					

JULY
M	T	W	T	F	S	S
		1	2	3	4	5
6	7	8	9	10	11	12
13	14	15	16	17	18	19
20	21	22	23	24	25	26
27	28	29	30	31		

AUGUST
M	T	W	T	F	S	S
					1	2
3	4	5	6	7	8	9
10	11	12	13	14	15	16
17	18	19	20	21	22	23
24	25	26	27	28	29	30
31						

SEPTEMBER
M	T	W	T	F	S	S
1	2	3	4	5	6	
7	8	9	10	11	12	13
14	15	16	17	18	19	20
21	22	23	24	25	26	27
28	29	30				

OCTOBER
M	T	W	T	F	S	S
			1	2	3	4
5	6	7	8	9	10	11
12	13	14	15	16	17	18
19	20	21	22	23	24	25
26	27	28	29	30	31	

NOVEMBER
M	T	W	T	F	S	S
						1
2	3	4	5	6	7	8
9	10	11	12	13	14	15
16	17	18	19	20	21	22
23	24	25	26	27	28	29
30						

DECEMBER
M	T	W	T	F	S	S
	1	2	3	4	5	6
7	8	9	10	11	12	13
14	15	16	17	18	19	20
21	22	23	24	25	26	27
28	29	30	31			

INTRODUCTION

Lady Beatrix Stanley was an accomplished gardener and artist. She spent five years living in India with her husband, Sir George Stanley, Governor of Madras from 1929 to 1934, and Viceroy and Acting Governor-General of India in 1934. Born the youngest daughter of the Marquees of Headfort in 1877, she inherited a love of plants and gardening. 'She was able to grow, propagate and distribute plants which baffled others,' and was generous with both her knowledge and skill, sharing unusual plants with other enthusiasts. The works reproduced here are a sample of the extensive collection of paintings she produced during her time in India.

Whilst living in Madras (now Chennai), Lady Beatrix was a keen observer of gardening practices in all the places she visited. Having left behind a wonderful garden in England, she sought to create a beautiful idyll in their new home. The couple's residence was in the south, in Ootacamund, or 'Ooty' for short, but there were plenty of opportunities to travel to the north, and she wrote with enthusiasm of the gardens in Agra and New Delhi. She had a passion for growing both her beloved plants from home as well as tropical varieties. She recommended that British gardeners in India should not try too hard to replicate an English garden, as lovely as it was to be reminded of home, but seek to embrace the native shrubs and creepers that she herself found interesting.

Already established as a horticultural authority, Lady Beatrix had developed an extensive knowledge of bulbous plants with her own collection in her garden at Sibbertoft Manor, Market Harborough in Leicestershire. Edward Augustus Bowles, an expert on crocuses (amongst various other horticultural accolades), records a visit by her to Myddleton House in February 1922 to view newly flowering varieties of crocuses and snowdrops. 'Aunt B', as she was affectionately known, was counted amongst his 'plant-hunting friends', having been in the party that travelled with Bowles to the Pyrenees in 1928. Whilst in India, Bowles and Lady Beatrix maintained weekly correspondence, with seeds from new plants being sent along with observations and photographs of her travels. Much of this correspondence survives in the RHS Archives. (E.A. Bowles Archives held by the RHS Lindley Library.)

There is unfortunately no record of where our artist learnt to paint, although it seems she may have been largely self-taught. Lady Beatrix's interest in using watercolours developed whilst she was in India, and she completed over 150 pictures of plants growing in and around the gardens she visited. In her letters to Bowles in 1931 she expresses concern at the quality of her painting, particularly in the composition of floral groups. She was keen to receive feedback and sent samples of her artwork to Myddleton House from Madras. Her loose painterly style, quite common of flower painters during the period, bears some similarity to that of Bowles. She need not have been worried, as her flower paintings were exhibited at the Chelsea Flower Show in 1930 and 1931, and on both occasions she was awarded a Silver-gilt Grenfell medal.

Bold and vibrant in style, these paintings are the work of a keen and dedicated plantswoman. They provide us with a fascinating insight into Lady Stanley's horticultural world as she diligently noted genus and species, locations and dates of the plants she painted. Seeking to portray her specimens with botanical accuracy, she clearly intended these works to be a record of her time in India.

Her time there was spent not just painting and gardening, but also fostering community relations. Lady Beatrix was the president of the Nilgiri Ladies' Club, based in Ootacamund, established in 1930 to promote social intercourse between Indian and European Women. In 1935 she was awarded the Imperial Order of the Crown of India (CI), a title only conferred to women, in recognition of her time spent in India.

On her return to England, Lady Beatrix immersed herself back in the world of British horticulture with long-established friends. She had been writing short essays and notes during her time overseas and returned to work on RHS committees. Following an article for the *RHS Lily Year Book* in 1935, she was appointed editor of *The New Flora and Sylva*, between 1938 and 1940.

She is honoured in the naming of two cultivated varieties: *Iris histrioides* 'Lady Beatrix Stanley' and *Galanthus* 'Lady Beatrix Stanley'.

DECEMBER/JANUARY

31 Monday New Year's Eve

01 Tuesday New Year's Day
 Holiday, UK, Republic of Ireland, USA,
 Canada, Australia and New Zealand

02 Wednesday Holiday, Scotland and New Zealand

03 Thursday

04 Friday

05 Saturday

06 Sunday New moon
 Epiphany

Watercolour of *Argyreia*, painted in India, c1930.

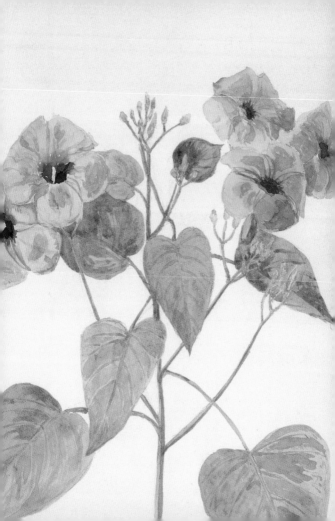

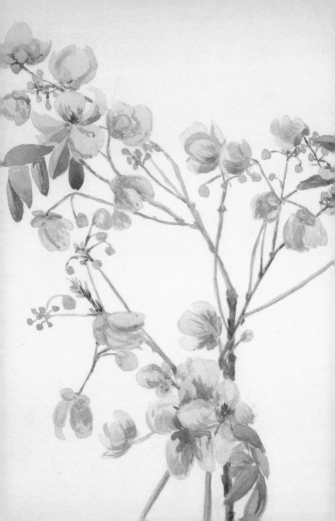

JANUARY

Monday 07

Tuesday 08

Wednesday 09

Thursday 10

Friday 11

Saturday 12

Sunday 13

Watercolour of *Senna siamea*, formerly known as *Cassia siamea glauca*, painted in India, c1930.

JANUARY

14 Monday

First quart

15 Tuesday

16 Wednesday

17 Thursday

18 Friday

19 Saturday

20 Sunday

Watercolour of *Habenaria longicornu* or long-horned habenaria. An orchid native to India, it was painted showing its natural habitat in India, c1930.

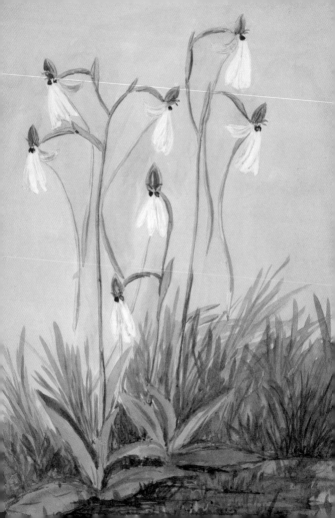

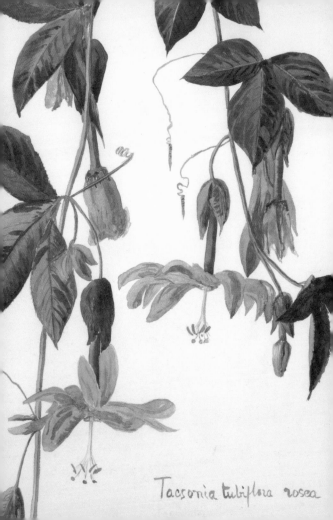

Tacsonia tubiflora rosea

JANUARY

Monday 21

moon
day, USA (Martin Luther King Jnr Day)

Tuesday 22

Wednesday 23

Thursday 24

Friday 25

stralia Day

Saturday 26

t quarter

Sunday 27

tercolour of *Tacsonia tubiflora rosea*, now believed to be *Passiflora mollissima*,
nted in Ootacamund, India, c1930.

JANUARY/FEBRUARY

28 Monday Holiday, Australia (Australia D

29 Tuesday

30 Wednesday

31 Thursday

01 Friday

02 Saturday

03 Sunday

Watercolour of a pink *Hibiscus*, painted in Madras, India, in 1930.

FEBRUARY

New moon

Monday 04

Chinese New Year

Tuesday 05

Accession of Queen Elizabeth II
Holiday, New Zealand (Waitangi Day)

Wednesday 06

Thursday 07

Friday 08

Saturday 09

Sunday 10

Watercolour of a *Hibiscus*, painted in India, c1930.

FEBRUARY

11 Monday

12 Tuesday *First qua*

13 Wednesday

14 Thursday Valentine's

15 Friday

16 Saturday

17 Sunday

Watercolour of *Ipomoea indica* or blue dawn flower, previously known as *Ipomoea learii*.
Painted in India, c1930.

FEBRUARY

Holiday, USA (Presidents' Day)

Monday 18

Full moon

Tuesday 19

Wednesday 20

Thursday 21

Friday 22

Saturday 23

Sunday 24

Watercolour on paper of *Watsonia pillansii* or Beatrice watsonia, previously known as *Watsonia beatricis*. Painted in Ootacamund, where Beatrix Stanley was in residence in southern India, in 1934.

FEBRUARY/MARCH

25 Monday

26 Tuesday

Last quar

27 Wednesday

28 Thursday

01 Friday

St David's D

02 Saturday

03 Sunday

Watercolour of *Tabebuia rosea* or pink trumpet tree, previously known as *Tecoma rosea*.
Painted in Ootacamund, India, c1930.

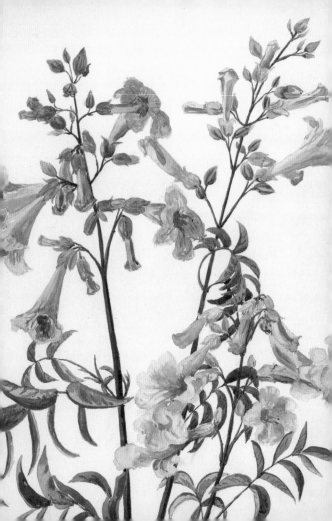

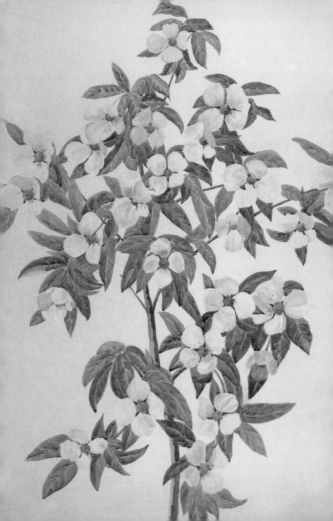

MARCH

Monday 04

ʳove Tuesday

Tuesday 05

ᵤ moon
ᴺ Wednesday

Wednesday 06

Thursday 07

Friday 08

Saturday 09

Sunday 10

ᵃtercolour on paper of *Cornus capitata*, the Himalayan evergreen dogwood. Painted in
imla in the Himalayan foothills, India, 1934.

MARCH

11 *Monday* Commonwealth I

12 *Tuesday*

13 *Wednesday*

14 *Thursday* *First qua*

15 *Friday*

16 *Saturday*

17 *Sunday* St Patrick's D

Watercolour of *Memecylon umbellatum* or iron wood tree, painted in India, c1930.
The inscription by the artist reads: 'From plant brought in from jungle by
Capt. Bootle Wilbraham', the Governor's Military Secretary.

iday, Northern Ireland and Republic
ɪreland (St Patrick's Day)

Monday 18

Tuesday 19

ɪnal Equinox (Spring begins)

Wednesday 20

ᵗ moon

Thursday 21

Friday 22

Saturday 23

Sunday 24

atercolour of *Tristellateia australasiae*, painted in India, c1930.

MARCH

25 Monday

26 Tuesday

27 Wednesday

28 Thursday Last qua

29 Friday

30 Saturday

31 Sunday Mothering Sunday, UK and Republic of Irela
 British Summer Time beg

Watercolour of *Oxalis*, painted in India, c1930.

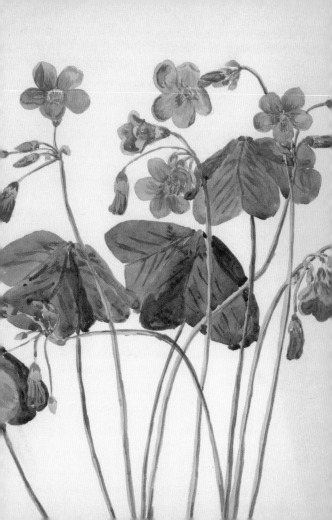

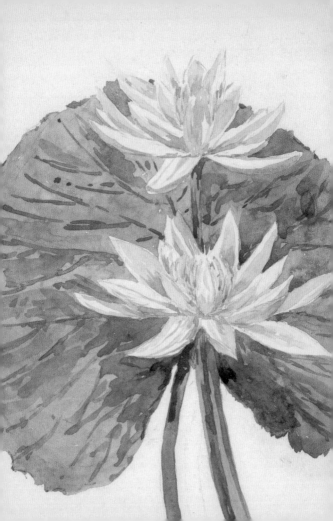

APRIL

Monday 01

Tuesday 02

Wednesday 03

Thursday 04

moon Friday 05

Saturday 06

Sunday 07

ᴇrcolour of *Nymphaea* or India lotus, painted in India, c1930.

APRIL

08 Monday

09 Tuesday

10 Wednesday

11 Thursday

12 Friday First qua

13 Saturday

14 Sunday Palm Sun

Watercolour of Oxalis, painted in India, c1930.

APRIL

Monday 15

Tuesday 16

Wednesday 17

undy Thursday

Thursday 18

moon
od Friday
liday, UK, Canada, Australia and New Zealand

Friday 19

st day of Passover (Pesach)

Saturday 20

ster Sunday
thday of Queen Elizabeth II

Sunday 21

atercolour of *Oxalis corniculata*, Indian penny wood or creeping wood sorrel,
inted in India, c1930.

APRIL

22 Monday

Easter Mon
Holiday, UK (exc. Scotland), Repu
of Ireland, Australia and New Zeala

23 Tuesday

St George's

24 Wednesday

25 Thursday

Holiday, Australia and New Zeal
(Anzac D

26 Friday

Last qua

27 Saturday

28 Sunday

Watercolour of *Hesperantha coccinea* or crimson flag lily, previously known as
Schizostylis coccinea, painted in India, c1930.

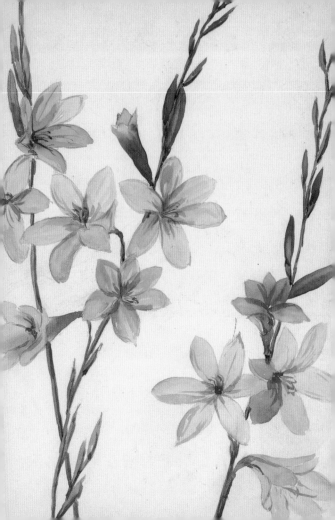

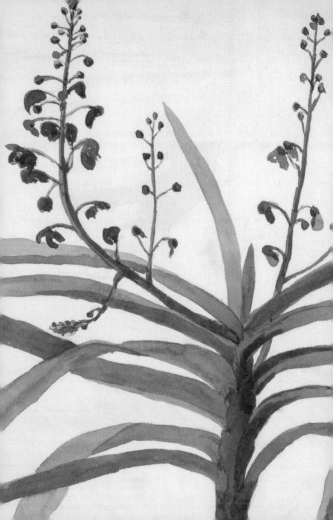

APRIL/MAY

Monday 29

Tuesday 30

Wednesday 01

Thursday 02

Friday 03

u moon

Saturday 04

Sunday 05

tercolour of *Aerides ringens*, previously known as *Aerides radicosum (A. radicosa)*. This small,
phytic orchid typically grows on tree bark and is native to India. Painted in India, c1930.

MAY

06 Monday

Early Spring Bank Holiday,
Holiday, Republic of Irela
First day of Ramad
(subject to sighting of the mo

07 Tuesday

08 Wednesday

09 Thursday

10 Friday

11 Saturday

12 Sunday

First quar
Mother's Day, USA, Cana
Australia and New Zeala

Watercolour of *Anemone vitifolia* (misnamed *Anemone vitifolium* by the artist), painted in Shimla, India, 1934.

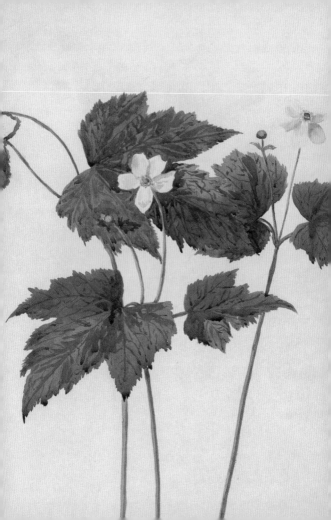

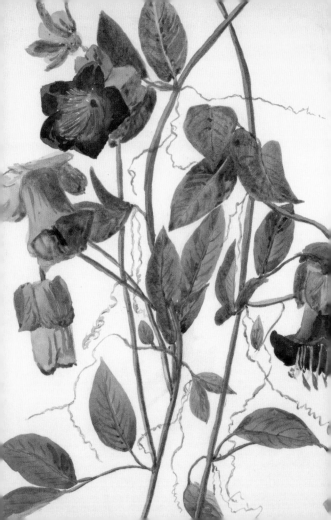

MAY

Monday 13

Tuesday 14

Wednesday 15

Thursday 16

Friday 17

moon

Saturday 18

Sunday 19

tercolour of *Cobaea scandens*, also known as the cup and saucer vine, painted in India, c1930.

MAY

20 Monday Holiday, Canada (Victoria D

21 Tuesday

22 Wednesday

23 Thursday

24 Friday

25 Saturday

26 Sunday Last qua

Watercolour of *Crotalaria* or Indian hemp, painted in India, c1930.

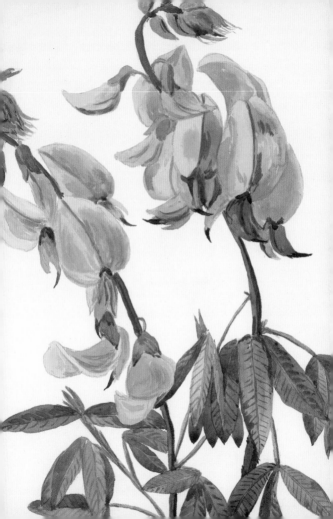

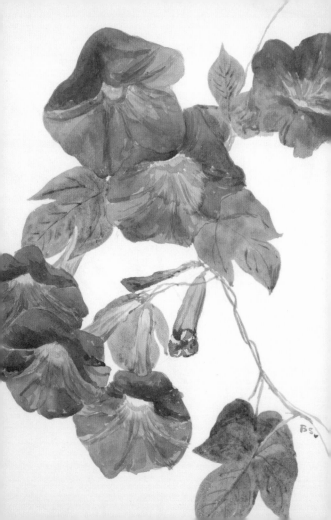

MAY/JUNE

ing Bank Holiday, UK
iday, USA (Memorial Day)

Monday 27

Tuesday 28

Wednesday 29

ension Day

Thursday 30

Friday 31

Saturday 01

nation Day

Sunday 02

ercolour of *Ipomoea indica* or blue dawn flower, previously known as *Ipomoea learii*,
ted in India, c1930.

JUNE

03 Monday

New m
Holiday, Republic of Irel
Holiday, New Zealand (The Queen's Birth

04 Tuesday

05 Wednesday

Eid al-Fitr (end of Rama
(subject to sighting of the m

06 Thursday

07 Friday

08 Saturday

The Queen's Official Birth
(subject to confirma

09 Sunday

Whit Su
Feast of Weeks (Sha

Watercolour of mixed *Cannas*, also known as canna lilies or Indian shot, painted
in India, 1930s.

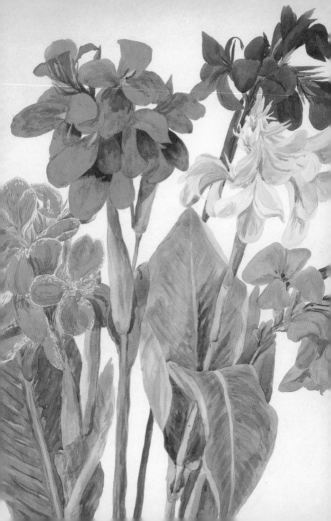

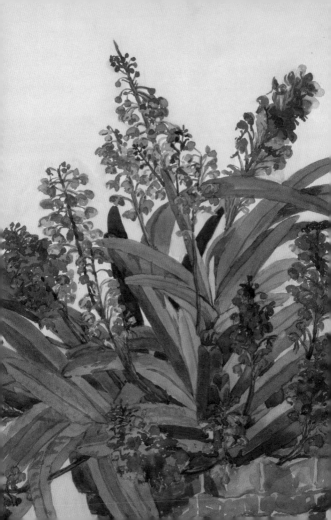

First quarter
Holiday, Australia (The Queen's Birthday)

Monday 10

Tuesday 11

Wednesday 12

Thursday 13

Friday 14

Saturday 15

Trinity Sunday
Father's Day, UK, Republic of Ireland,
USA and Canada

Sunday 16

Watercolour of *Aerides ringens*, painted in Ootacamund, southern India, 1933.

JUNE

17 Monday Full mo

18 Tuesday

19 Wednesday

20 Thursday Corpus Chr

21 Friday Summer Solstice (Summer begi

22 Saturday

23 Sunday

Watercolour of *Barleria cristata*, painted in India, c1930.

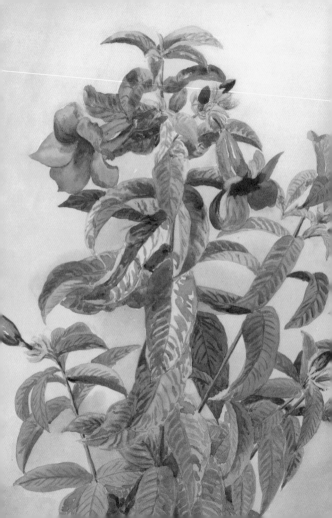

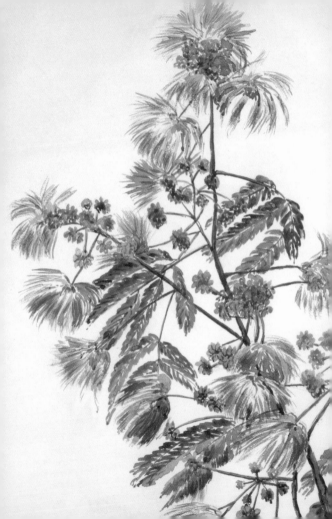

JUNE

Monday 24

t quarter

Tuesday 25

Wednesday 26

Thursday 27

Friday 28

Saturday 29

Sunday 30

tercolour of *Albizia julibrissin* f. *rosea* or pink silk tree, painted in India, c1930.

JULY

01 *Monday* Holiday, Canada (Canada D

02 *Tuesday* *New m*

03 *Wednesday*

04 *Thursday* Holiday, USA (Independence D

05 *Friday*

06 *Saturday*

07 *Sunday*

Watercolour of *Bauhinia purpurea* or butterfly tree, painted in Madras, India, c1930.

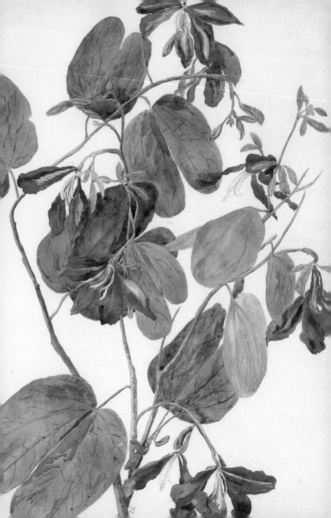

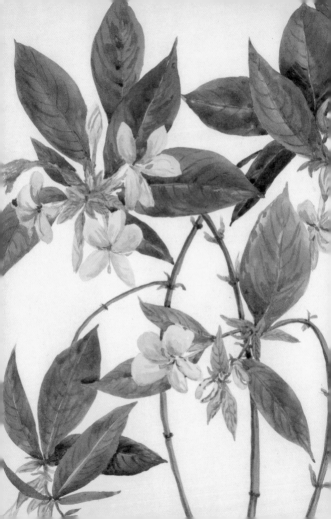

JULY

Monday 08

quarter *Tuesday* 09

Wednesday 10

Thursday 11

…day, Northern Ireland (Battle of the Boyne) *Friday* 12

Saturday 13

Sunday 14

…ercolour of *Barleria involucrata* var. *elata*, now thought to be *B. cristata*,
…ted in India, c1930.

JULY

15 Monday St Swithin's

16 Tuesday Full

17 Wednesday

18 Thursday

19 Friday

20 Saturday

21 Sunday

Watercolour of *Hibiscus*, painted in Madras, India, c1930.

JULY

Monday 22

Tuesday 23

Wednesday 24

quarter

Thursday 25

Friday 26

Saturday 27

Sunday 28

Watercolour of *Cassia didymobotrya* or golden wonder, painted in India, c1930.

JULY/AUGUST

29 Monday

30 Tuesday

31 Wednesday

01 Thursday *New*

02 Friday

03 Saturday

04 Sunday

Watercolour of *Brownea grandiceps* or rose of Venezuela and *Brownea coccinea* × *latifolia*, previously known as *Brownea coccinea*, painted in India, c1930.

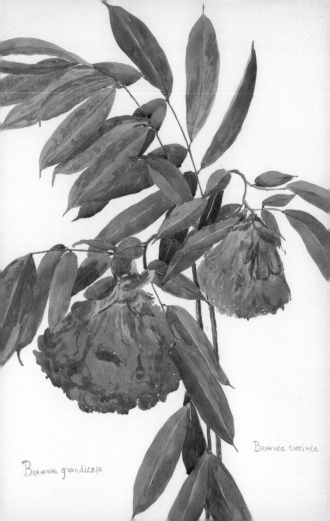

Brownea coccinea.

Brownea grandiceps

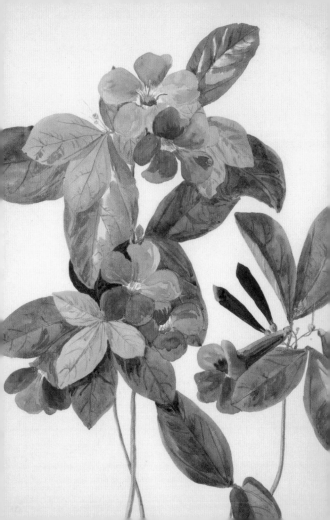

AUGUST

oliday, Scotland and Republic of Ireland

Monday 05

Tuesday 06

st quarter

Wednesday 07

Thursday 08

Friday 09

Saturday 10

Sunday 11

ercolour of *Bignonia magnifica*, painted in India, c1930.

AUGUST

12 Monday

13 Tuesday

14 Wednesday

15 Thursday
Full m

16 Friday

17 Saturday

18 Sunday

Watercolour of *Butea monosperma*, commonly known as flame of the forest, previously know
as *Butea frondosa*, painted in India, c1930.

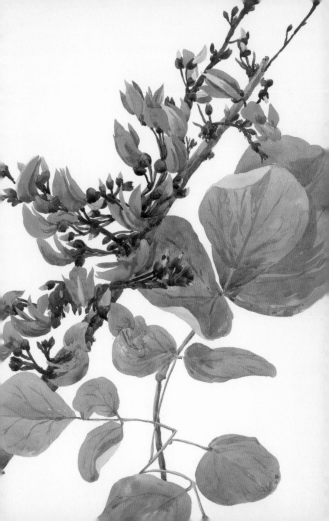

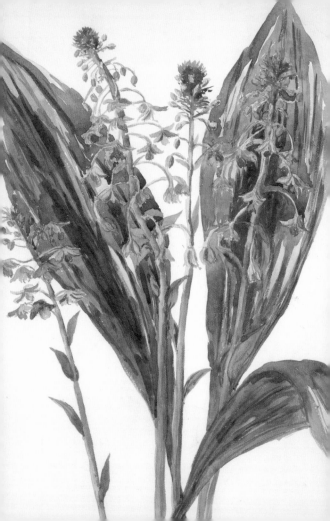

AUGUST

Monday 19

Tuesday 20

Wednesday 21

Thursday 22

First quarter *Friday* 23

Saturday 24

Sunday 25

Watercolour of *Calanthe triplicata*, previously known as *Calanthe veratrifolia*. This orchid is commonly found in southern India. Painted in India, c1930.

26 Monday

Summer Bank Holiday, UK (exc. Scotla

27 Tuesday

28 Wednesday

29 Thursday

30 Friday

New m

31 Saturday

01 Sunday

Islamic New Y
Father's Day, Australia and New Zeala

Watercolour of *Caesalpinia pulcherrima*, painted in Madras, India, c1930.

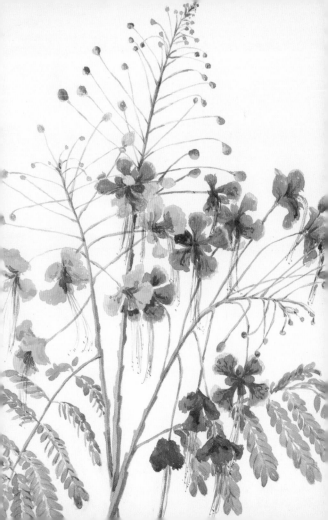

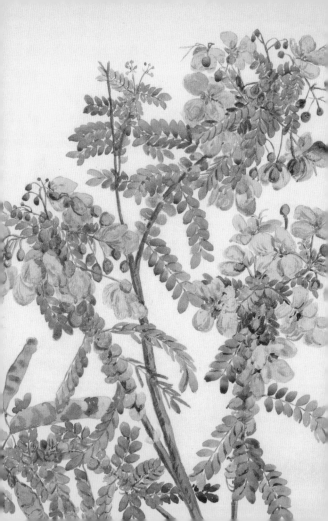

SEPTEMBER

Monday 02

Tuesday 03

Wednesday 04

Thursday 05

quarter

Friday 06

Saturday 07

Sunday 08

ercolour of *Senna auriculata* or avaram, it was previously known as *Cassia auriculata*.
ᴛed in India, c1930.

SEPTEMBER

09 Monday

10 Tuesday

11 Wednesday

12 Thursday

13 Friday

14 Saturday Full m

15 Sunday

Watercolour of *Calotropis gigantea* or Indian bowstring hemp, painted in India, c1930.

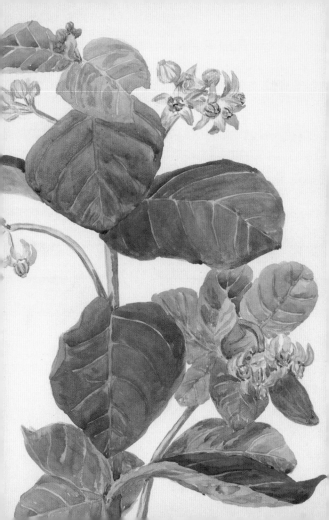

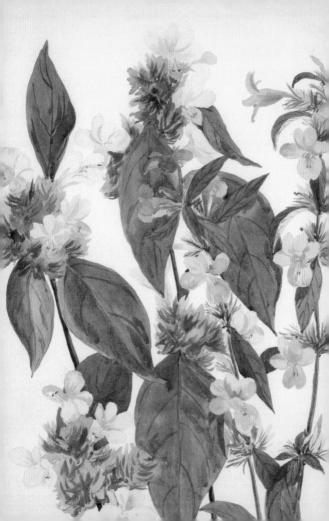

SEPTEMBER

Monday 16

Tuesday 17

Wednesday 18

Thursday 19

Friday 20

Saturday 21

uarter

Sunday 22

colour of *Barleria cristata rosea* and *Barleria strigosa*, found growing in the foothills
Himalayas. Painted in India, c1930.

SEPTEMBER

23 Monday Autumnal Equinox (Autumn be

24 Tuesday

25 Wednesday

26 Thursday

27 Friday

28 Saturday New

29 Sunday Michaelma

Watercolour of *Couroupita guianensis* or cannonball tree, painted in India, c1930.

SEPTEMBER/OCTOBER

...sh New Year (Rosh Hashanah)

Monday 30

Tuesday 01

Wednesday 02

Thursday 03

Friday 04

quarter

Saturday 05

Sunday 06

...rcolour of *Cochlospermum gossypium*, painted in India, c1930.

OCTOBER

07 Monday

08 Tuesday

09 Wednesday Day of Atonement (Yom Kip

10 Thursday

11 Friday

12 Saturday

13 Sunday Full

Watercolour of *Fagraea obovata*, painted in India, c1930.

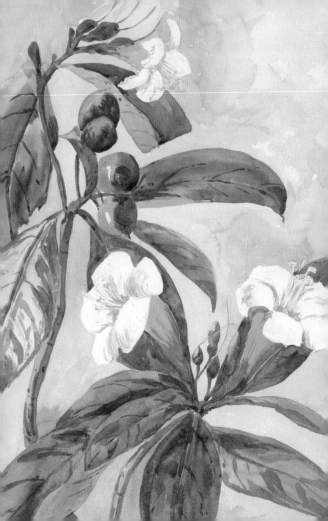

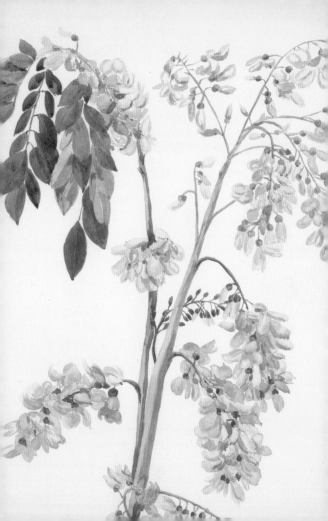

OCTOBER

st day of Tabernacles (Succoth)
liday, USA (Columbus Day)
liday, Canada (Thanksgiving)

Monday **14**

Tuesday **15**

Wednesday **16**

Thursday **17**

Friday **18**

Saturday **19**

Sunday **20**

ercolour of *Gliricidia sepium* or madre de cacao/mother of cocoa, previously known as
cidia maculata, painted in Madras, India, c1930.

OCTOBER

21 Monday

Last qu

22 Tuesday

23 Wednesday

24 Thursday

25 Friday

26 Saturday

27 Sunday

British Summer Time

Watercolour of *Beaumontia grandiflora* or Nepal trumpet flower, painted in Madras, India, c19

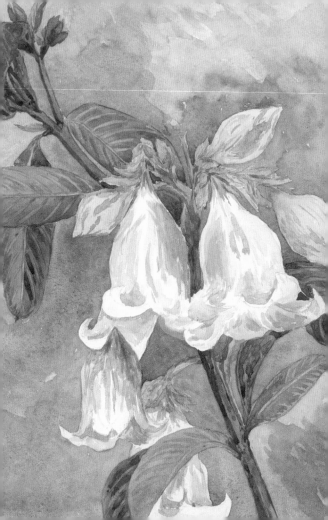

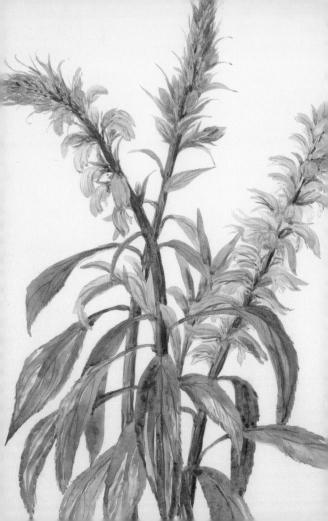

OCTOBER/NOVEMBER

moon
.day, Republic of Ireland
.day, New Zealand (Labour Day)

Monday 28

Tuesday 29

Wednesday 30

loween

Thursday 31

Saints' Day

Friday 01

Saturday 02

Sunday 03

tercolour of *Digitalis canariensis*, previously known as *Isoplexis canariensis*, originally
n the Canary Islands. Painted in India, c1930.

NOVEMBER

04 Monday *First qu*

05 Tuesday Guy Faw

06 Wednesday

07 Thursday

08 Friday

09 Saturday

10 Sunday Remembrance Sun

Watercolour of *Datura sanguinea*, painted in Ootacamund, India, c1930.

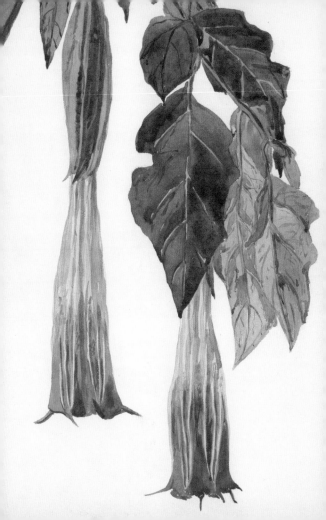

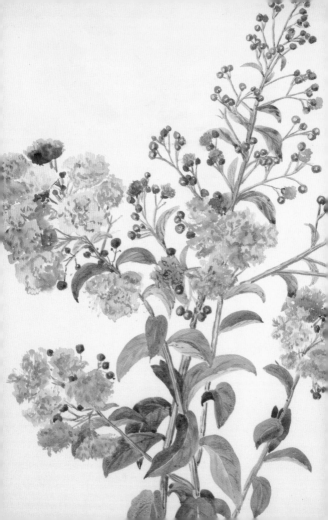

NOVEMBER

ay, USA (Veterans Day)
ay, Canada (Remembrance Day)

Monday **11**

.oon

Tuesday **12**

Wednesday **13**

Thursday **14**

Friday **15**

Saturday **16**

Sunday **17**

colour of *Lagerstroemia indica* or crape myrtle, painted in India, c1930.

NOVEMBER

18 Monday

19 Tuesday

20 Wednesday

21 Thursday

22 Friday

23 Saturday

24 Sunday

Watercolour of *Ochna squarrosa* or golden champak, painted in India, c1930.

Monday 25

moon

Tuesday 26

Wednesday 27

.iay, USA (Thanksgiving)

Thursday 28

Friday 29

.ndrew's Day

Saturday 30

Sunday in Advent

Sunday 01

rcolour of *Phaedranassa aurantiaca*, now identified as *Stenomesson miniatum*,
.ed in India, c1930.

DECEMBER

02 Monday

03 Tuesday

04 Wednesday

05 Thursday

06 Friday

07 Saturday

08 Sunday

Watercolour of *Prunus cerasoides* or wild Himalayan cherry, previously known as *Prunus puddum*, painted in India, c1930.

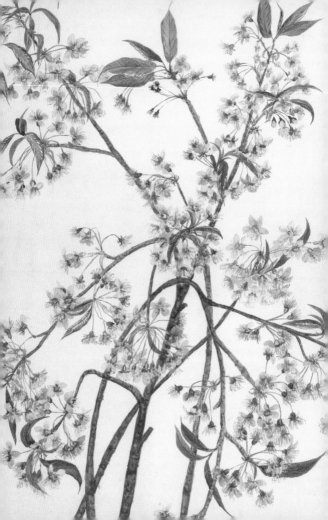

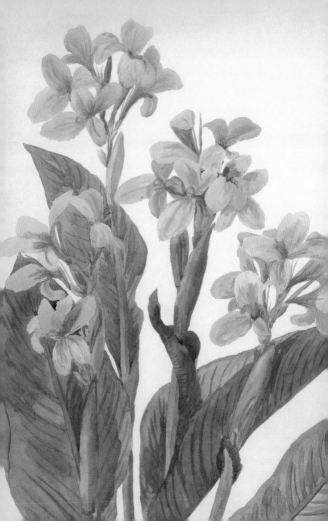

DECEMBER

Monday 09

Tuesday 10

Wednesday 11

moon *Thursday* 12

Friday 13

Saturday 14

Sunday 15

ercolour of canna lilies, painted in India, 1930s.

DECEMBER

16 Monday

17 Tuesday

18 Wednesday

19 Thursday

Last qu

20 Friday

21 Saturday

22 Sunday

Winter Solstice (Winter be
Hannukah begins (at su

Watercolour of *Salvia involucrata* 'Bethellii' or rosy-leaf sage, previously known
as *Salvia bethellii*, painted in India, c1930.

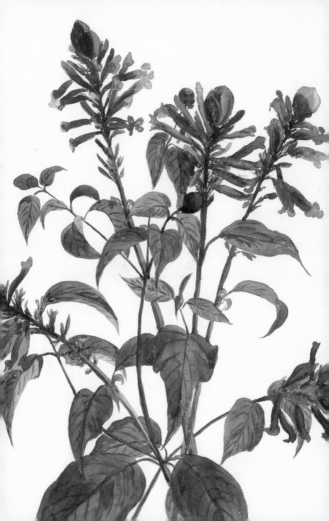

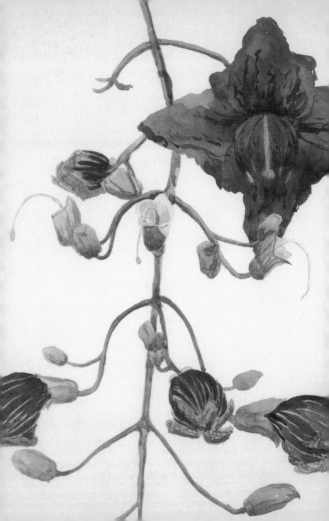

DECEMBER

Monday 23

tmas Eve

Tuesday 24

tmas Day
ay, UK, Republic of Ireland,
Canada, Australia and New Zealand

Wednesday 25

moon
g Day (St Stephen's Day)
lay, UK, Republic of Ireland,
da, Australia and New Zealand

Thursday 26

Friday 27

Saturday 28

Sunday 29

rcolour of *Kigelia pinnata* or sausage tree, painted in India, c1930.

30 Monday Hannukah

31 Tuesday New Year'

01 Wednesday New Year's
 Holiday, UK, Republic of Ireland,
 Canada, Australia and New Zea

02 Thursday Holiday, Scotland and New Zea

03 Friday

04 Saturday

05 Sunday

Watercolour on paper of *Zantedeschia aethiopica* or calla lily, previously known as
Richardia africana, painted in India, 1930s.

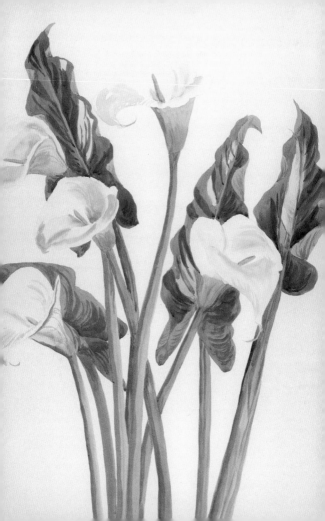

YEAR PLANNER

JANUARY	JULY

FEBRUARY	AUGUST

MARCH	SEPTEMBER

APRIL	OCTOBER

MAY	NOVEMBER

JUNE	DECEMBER